# The Art of Prayer

## Fall Into His Grace

Draw closer to God as you receive the grace you need.

# The Art
# of
# Prayer

## *Fall Into His Grace*

Draw closer to God as you
receive the grace you need.

*Bible translations used in the creation of this book are*:

*"For you have been delivered by grace through trusting, and even this is not your accomplishment but God's gift. You were not delivered by your own actions; therefore no one should boast."*
Ephesians 2:8-9, CJB

Everyday the world sends us the message that we must do more, be more, have more.

*We work hard to accomplish.*
*We play hard to win.*

It has been said that autumn shows us how beautiful it is to let things go.

My prayer is that as you spend time in this book that you will truly let go of the impossible expectations the world places on us, and truly accept the grace that God desires for you to have. You don't have to earn it. You don't have to work for it, or perform for it. You simply have to receive it by trusting the One who made grace possible—Jesus Christ.

Once you have made the decision to fully trust Christ with your heart, you can find the beauty of letting go, and experience the rest that comes from falling into His grace—the grace He brought and made possible for everyone. The grace He made possible for *you*.

You may be navigating a journey that desperately needs grace. Perhaps there's a relationship that needs a fresh seasoning of grace. Maybe you are having trouble believing that grace is available to you, after everything you've done. Or could it be that you need to give grace to someone who has deeply wounded you?

*There is gracious Giver that longs to have you open His gift of grace.*

In these pages, you will find comforting Scripture to color, and then areas where you can journal or draw prayers as you consider the Scriptures you read. There are no rules or guidelines, no right or wrong way to do this. Simply choose an art medium you like to work with—colored pencils, crayons, markers—and open this book. This way of praying is for the amateur or the professional, the optimistic attitude or the skeptic heart. Using the ***Art of Prayer***, you will connect with God in an intimate way that is recorded with images and journaled thoughts. This record will remind you of His faithfulness on the tough days, and it will encourage you as you allow yourself to truly fall into His grace.

Warmly,
Rev. Lori Hartin
CEO/Founder
Ladybug Women's Ministries, Inc.

"I don't live for my art,
my art lives for me
because my art is me
and I am living."

—Julie Raworth

I am saved by grace.

Ephesians 2:8

Have you received the gift of God's grace?
Draw or journal your thoughts here....

For by grace you have been saved through faith, and this is
not of yourselves. It is the gift of God,
Ephesians 2:8, MEV

I am justified by His grace...

Romans 3:24

You were on God's mind before you ever called on His
name. How does knowing that help you today?
Draw or journal your thoughts here....

...for all have sinned and fall short of the glory of God; being justified
freely by His grace through the redemption that is in Christ Jesus;
Romans 3:23-24, WEB

But grace was given to each one of us...

Ephesians 4:7

God has given you unique gifts. He doesn't want you to walk and talk like everyone else. When have you been tempted to compare yourself with others?

Draw or journal your thoughts here....

But to each one of us was the grace given according to the measure of the gift of Christ.

Ephesians 4:7, WEB

My grace is sufficient for you...

2 Corinthians 12:9

Do you believe that God's grace is enough, that it's really all you need?

Draw or journal your thoughts here....

Concerning this thing, I begged the Lord three times that it might depart from me. He has said to me, "My grace is sufficient for you, for my power is made perfect in weakness." Most gladly therefore I will rather glory in my weakness, that the power of Christ may rest on me.

2 Corinthians 12:8-9, WEB

His grace
restores me...

1 Peter 5:10

God has promised to restore you with His grace after times of suffering. How does this encourage you in your current journey?

Draw or journal your thoughts here....

But may the God of all grace, who called you to His eternal glory by Christ Jesus, after you have suffered a little while, perfect, establish, strengthen, and settle you.

I Peter 5:10, WEB

I am who
I am because
of God's
grace.

1 Corinthians 15:10

Recall a time when you knew God's grace was working through you. What was the effect?

Draw or journal your thoughts here....

But by the grace of God I am what I am. His grace which was given to me was not futile, but I worked more than all of them; yet not I, but the grace of God which was with me.

I Corinthians 15:10, WEB

Grace and
truth came
through
Jesus Christ

John 1:17

The law reminds us that we are broken. Grace reminds us that we are loved. How does this speak to your heart? Draw or journal your thoughts here....

For the law was given through Moses. Grace and truth were realized through Jesus Christ.

John 1:17, WEB

Let your words be full of grace...

**Colossians 4:6**

Who can you speak gracefully to today?
Draw or journal your thoughts here....

Let your speech always be with grace, seasoned with salt, that you may
know how you ought to answer each one.
Colossians 4:6, WEB

He gives grace
to the humble.

Proverbs 3:34

When is it most challenging to be humble?
Draw or journal your thoughts here....

Surely He mocks the mockers, but He gives grace to the humble.
Proverbs 3:34, WEB

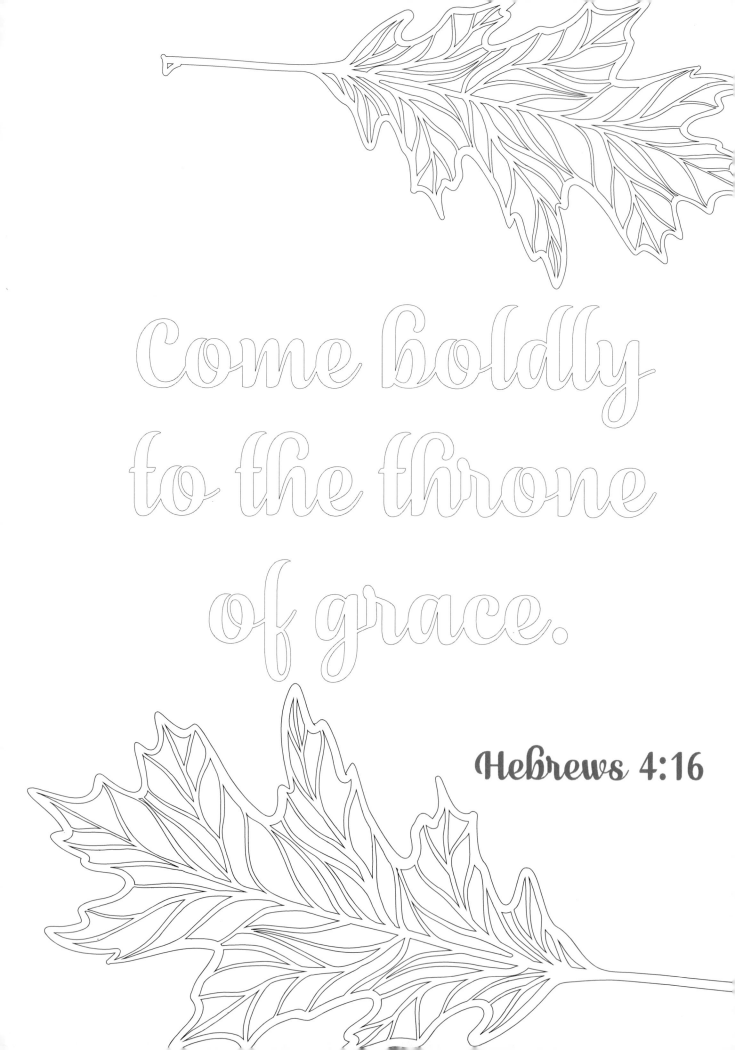

Come boldly to the throne of grace.

Hebrews 4:16

Do you approach God's throne freely and boldly?
Draw or journal your thoughts here....

Let us therefore draw near with boldness to the throne of grace, that we
may receive mercy, and may find grace for help in time of need.
Hebrews 4:16, WEB

God can give
you more grace
than you'll ever
need.

2 Corinthians 9:8

How does it feel to know that God is ready to overwhelm you with more grace than you could ever imagine?
Draw or journal your thoughts here….

And God is able to make all grace abound to you, that you, always having all sufficiency in everything, may abound to every good work.
2 Corinthians 9:8, WEB

Be empowered by the grace of Jesus.

2 Timothy 2:1

Are you living your life empowered by God's grace?
Draw or journal your thoughts here....

You therefore, my child, be strengthened in the grace
that is in Christ Jesus.
2 Timothy 2:1, WEB

The grace of God has appeared...

Titus 2:11

God's grace made salvation possible for everyone. Who do you know that needs salvation today?

Draw or journal your thoughts here....

For the grace of God has appeared, bringing salvation to all men,
Titus 2:11, WEB

The Lord will give grace and glory...

Psalm 84:11

What do you need God to shield you from today?
Draw or journal your thoughts here...

For the LORD God is a sun and a shield. The LORD will give grace and glory. He withholds no good thing from those who walk blamelessly.
Psalm 84:11, NHEB

May grace and peace be yours...

2 Peter 1:2

Are you seeking God for an increase of grace and peace?
Draw or journal your thoughts here....

May grace and peace ever be increasing in you, in the knowledge of God
and of Jesus our Lord;

2 Peter 1:2, BBE

But He gives
more grace...

James 4:6

As you practice humility, God responds with providing more grace. How does this help you today?
Draw or journal your thoughts here....

But He gives more grace. Therefore it says, "God resists the proud, but gives grace to the humble."
James 4:6, WEB

Thank You, God, for the message of your grace...

Acts 20:32

Who do you need to entrust to God's care, and to the word of His grace?

Draw or journal your thoughts here....

And now, I give you into the care of God and the word of His grace, which is able to make you strong and to give you your heritage among all the saints.

Acts 20:32, BBE

May God be gracious to us...

Psalm 67:1

Have you asked God to pour out His grace and
favor on your day?

Draw or journal your thoughts here....

May God be gracious to us, and bless us,
and cause His face to shine on us; Selah
Psalm 67:1, MEV

# I am under grace.

## Romans 6:14

How does it feel to no longer be a slave to sin?
Draw or journal your thoughts here....

For sin will not have dominion over you.
For you are not under law, but under grace.
Romans 6:14, WEB

You are a God of grace and mercy.

Nehemiah 9:31

Because of His grace, God will never forsake you. How does knowing this help you in your current season? Draw or journal your thoughts here....

Even then, in Your great mercy, You did not put an end to them completely, or give them up; for You are a God of grace and mercy.
Nehemiah 9:31, BBE

# Ladybug Women's Ministries

Ladybugs are tiny, but they serve such an important purpose in the cycle of nature. Our organization is committed to reminding every woman that even though she may feel tiny and unnoticed, she—just like the ladybug—plays an important role in God's plan for those around her. No job, no service, no contribution is useless!

Through Bible study, education scholarships, mentoring, speaker training, conversation, and support we work to encourage, equip, and empower women everywhere.

Ladybug Women's Ministries
PO Box 601233
Sacramento, CA  95860
www.LadybugMinistries.org

*Ladybug Women's Ministries, Inc. is a 501(c)(3) nonprofit organization.*